The Beginner's Guide to Chinese Calligraphy

An Introduction to *Kaishu* (Standard Script)

by Yi Yuan
Xiong Mingxiang

Better Link Press

This book is edited and designed by the Editorial Committee of *Cultural China* series.

Managing Directors: Wang Youbu, Xu Naiqing

Editorial Director: Wu Ying

Editors: Zhou Kexi, Yang Xiaohe, Mina Tenison

Assistant Editor: Jiang Junyan

Text by Yi Yuan, Xiong Mingxiang

Translation by Jiang Yajun, Chen Xiang

Interior and Cover Design: Yuan Yinchang, Xue Wenqing, Hu Bin

ISBN: 978-1-60220-113-2

Address any comments about *The Beginner's Guide to Chinese Calligraphy: An Introduction to* Kaishu *(Standard Script)* to:

Better Link Press

99 Park Ave

New York, NY 10016

USA

or

Shanghai Press and Publishing Development Co., Ltd.

F 7 Donghu Road, Shanghai, China (200031)

Email: comments_betterlinkpress@hotmail.com

Printed in China by Shenzhen Donnelley Printing Co., Ltd.

5 7 9 10 8 6 4

Contents

Preface......................5

A Brief History of Chinese Calligraphy......................7

Preparation for Writing *Kaishu*......................21

Introducing the Basic Strokes......................27

Exercises......................31

 Basic Strokes......................33

 Common Chinese Characters......................54

 Groups of Characters......................66

Gallery......................71

Appendices......................76

 Index of Calligraphers & Works......................77

 Chronology of Chinese History......................78

 Bibliography......................79

 Glossary......................80

Preface

As one of the most fascinating artistic forms in the world, Chinese calligraphy has long been an area of interest to both novices and researchers.

The purpose of this introductory book is two-fold. On one hand, it contains a short history of Chinese calligraphy and an introduction to *Kaishu* style (standard script), which embodies the very essence of the "Oriental arts" for those who find themselves interested in arts of East Asian countries. On the other hand, for those who know about Chinese calligraphy and want to try their hand at it, the book, with standard script as a starting point, introduces the basic skills of the ancient and exquisite art of Chinese calligraphy. The rules and methods contained in the book will make the learning process easier with clear diagrams and images.

A Brief History of Chinese Calligraphy

As you enjoy the strokes of voluptuous beauty in the Chinese calligraphic works, focus your attention on something more than calligraphy itself, notably, the Chinese history and cultural tradition, into which the calligraphy was born and with which it has been developing as a form of art. You may wonder: where does the calligraphic beauty come from? Like any other form of art in the world, calligraphy in China owes its glory to its creator, the calligrapher, "Art is life," as is believed. It was the legendary lives of the many calligraphers that gave birth to the Chinese calligraphy as the "most Chinese" form of art. As Liu Xizai, a renowned calligraphic critic in the Qing Dynasty (1644–1911), rightly observed, "A calligraphic work of art mirrors life. It is the culmination of the calligrapher's learning, talent, and aspiration. In a word, it becomes what the calligrapher is."

When it comes to the beauty of brush calligraphy, Wang Xizhi (303–361) and Yan Zhenqing (709–785) are household names in China. Stories about them have been passed from one generation to the next. Wang was a calligrapher who eclipsed all his contemporaries during the Eastern Jin period of the Southern and Northern Dynasties (420–589). Acknowledged as the "Sage of Calligrapher," he is often referred to as the greatest artist in the history of the field. While his authentic works are difficult to find due to passage of time, his masterpieces are still considered the highest realm a calligrapher can reach. The extant copy of his *Preface to the Orchid Pavilion Collection* (Figure 1) is an imitation by a court calligrapher in the Qing Dynasty. The work is better known for the

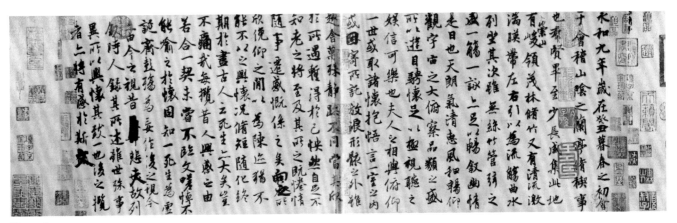

Figure 1

manner in which it was done: On March 3, the ninth year of Yonghe (353), Wang Xizhi, along with more than forty of others, was at the Orchid Pavilion in Shanyin (suburb of present Shaoxing city, Zhejiang Province) to celebrate the coming of spring. The gentle breeze and the shining sun must have delighted the brushes of the tipsy men of letters and, as a result, 26 pieces of poems were composed. Wang was recommended to write a preface to make an edited collection. On alcoholic strength, he finished composing and writing the 324 Chinese characters in 28 lines, in a very short time. It was said that Wang tried to better it, but in vain, leaving intact the copy of masterpiece known throughout the ages. With fine and exquisite strokes, and graceful and coherent wording, the piece is permeated with an atmosphere of the happiness and cheerfulness the calligrapher must have enjoyed. Although only a draft, the *Preface to the Orchid Pavilion Collection* is the earliest model in history that calligraphers have tried to follow, not only because it pioneered the calligraphic style of "freedom and elegance," but also because it upheld the tradition of "art representing life."

Nearly 400 years later in the Tang Dynasty (618–907), Yan Zhenqing, a statesman and calligrapher, immortalized his name in the history of Chinese calligraphy in the year of 758 with his *Draft of the Eulogy for My Nephew*. Different from the *Preface to the Orchid Pavilion Collection*, Yan's masterpiece is about a soul-stirring tragedy, an eulogy of Yan Jiming, his nephew, who, along with his father, fought against a rebellious army in the An Lushan-Shi Siming Rebellion in the years of Tianbao in the Tang Dynasty. Defeated, Yan Jiming and his father were killed. In a grievous and indignant mood, Yan Zhenqing

composed the 25 lines of the poem, with a total of 234 Chinese characters, when the head of his nephew was brought to him. While the first 12 lines were written in a controlled tone of voice, the rest is permeated with the great grief of losing one's dearest, with varied touches of the brush and uneven spaces between characters and lines. In particular, the concluding part, which must have been done swiftly, gives a hint as to the magnitude of his grief. The *Draft of the Eulogy for My Nephew* is among the few of Chinese calligraphic works that bring out the beauty of tragedy.

The above few examples demonstrate the stories behind every single piece of calligraphy. Calligraphy is not just about the right number of strokes; it is a meditation on art as life. Treat this book like a journey to the realm of Chinese calligraphy, and it will ever delight you, and help you gain a better understanding of the art.

Beauty of Simplicity: From the Shang to the Eastern Han Dynasty (1600 BC–AD 220)

The history of written script in China can be traced back to as far as 4,000 years ago, from the archeological evidence. The earliest symbols found on pottery from the prehistoric period are more pictorial, but they were no doubt the earliest written forms that Chinese ancestors used to express meaning and keep a record of events. As the society evolved, pictographs were created to express more complicated ideas, and the earliest of

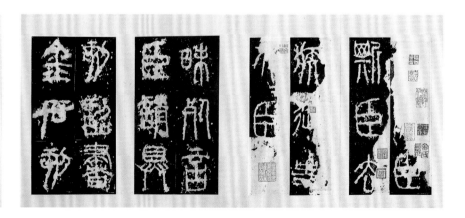

Figure 2

these available is *Jiaguwen* (oracle bone script) excavated from Yin Ruins in Anyang, Henan Province (Figure 2: Inscriptions on ox bones and rubbings in the Shang Dynasty, 1600–1046 BC). Oracle bone script are symbols inscribed into tortoise shells or ox bones with sharp tools. They are very simple both in style and technique, and pictographic in nature. In the late Yin Dynasty, as a result of the development in metallurgical techniques, people were able to produce fine vessels, and the inscriptions, called *Jinwen* (bronze script), were etched on them. Compared with oracle bone script, bronze script is more regular and shows more graceful lines. Bronze script was used and improved until the Spring and Autumn and Warring States (770–221 BC), during which, in addition to vessel scripts, scripts on other materials were found. These included, among others, *Shiguwen*, one of the earliest stone inscriptions, *Boshu*, written by ink and brush on textile materials, and *Jiandu*, writing on wood or bamboo with brush. Bronze script, among other early Chinese scripts, contributed greatly to the developmental trend of naturalness and simplicity of Chinese calligraphy in both structural composure and spatial arrangement.

In the Qin Dynasty (221–206 BC), the first Chinese feudal dynasty established in 221 BC, Li Si (284–208 BC), the Prime Minister, for the first time in Chinese history launched a campaign to promote *Xiaozhuan* (small-seal script) as the only standard writing style. As shown from the available rubbings from the stone inscriptions of the time, small-seal script (Figure 3), in contrast with the earlier scripts, features calligraphic harmony and balance, representing an era of laws and regulations in

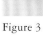

Figure 3

9

Chinese calligraphy. A different development can also be seen from the available evidence of the Qin calligraphy: a style called *Lishu* (clerical script). Clerical script of the Qin Dynasty, called *Qinli*, documented the subtle change to a new style with distinct contrasts between thinner and thicker lines and rising and falling strokes, indicating a new era in writing style.

The Han Dynasty (206 BC–AD 220) is an important period in the development of Chinese calligraphy. On the one hand, calligraphy became a popular activity due to the cultural and academic prosperity in the period; on the other, the improvement in brush making and the invention and use of paper accelerated the development of calligraphy in the Han Dynasty. Clerical script became the standard script in the Han Dynasty, having replaced small-seal script, and the maturation of the new style is evident in the evolution from *Jianshu* (writing on wood or bamboo with brush) in the Western Han Dynasty (206 BC–AD 25) to the tablet inscriptions in the Eastern Han Dynasty (25–220). Clerical script, found on the stone in the Han Dynasty has its distinct features: It is much less pictographic in composure, neater and more squat-shaped in form, and with more regular strokes. These features were the basis from which the contemporary Chinese characters developed their forms. The change from small-seal script to clerical script, taking place in the Han Dynasty, represents a huge revolution in the history of the development of the Chinese script.

At the end of the Eastern Han Dynasty, a few calligraphers began to brush in a free and artistic manner, making the practical work of writing a form of art. The result was the rise of the three individualized styles of *Caoshu* (cursive script), *Kaishu* (standard script), and *Xingshu* (running script).

The calligraphic changes from oracle bone script to bronze script and from small-seal script to clerical script represented an evolution from complexity to simplicity, which not only perfected calligraphy as a practical system of writing, but created an art form.

Beauty of Grace: The Three Kingdoms, Jin, and the Southern and Northern Dynasties (220–589)

The period from the Three Kingdoms (220–280), through Wei (220–265) and Jin (265–420), to the Southern and Northern Dynasties is even of greater importance in the development of the art of Chinese calligraphy. While the previous dynasties were periods of evolution, the new era was one of pure artistic interests. Especially in the Western and Eastern Jin dynasties, a number of intellectual elites from notable families and great clans, while retired from politics, were extremely pious observers of Buddhism and fond of literary activities and, as a result, resorted to calligraphy to express themselves, making their period one of the great "calligrapher-sages." They left to the later generations volumes of masterpieces, while contributing greatly to the unbelievably quick development of standard script, running script, and clerical script. Their personal genres also differed markedly.

Wang Xizhi and his son, Wang Xianzhi, were the two

greatest calligraphers of the Wei and Jin dynasties.

Wang Xizhi, the father, was born to a family in Langya, Linyi (Shangdong Province), where he learned calligraphy as a boy. He is referred to as the "Sage of Calligraphy," as he inherited, with extraordinary power of comprehension, the techniques of his predecessors while replacing the style of simplicity, which dominated the field ever since the Han and Wei dynasties, with his own genre, which featured the beauty of freedom and grace. Wang's standard script and running script have been used as models ever since by other calligraphers, who have been inspired by his pieces. In the Tang Dynasty, his status as the "Sage of Calligraphy" was further strengthened since Tang Taizong, the Emperor, praised him for his works. Unfortunately, none of his original works remains today. What are seen today are imitations of his pieces by Tang calligraphers, and the majority of them are running script pieces, including *Letter to My Aunt*, *Timely Clearing after Snowfall*, and the *Preface to the Orchid Pavilion Collection*, which is regarded as the "World No. 1 Running Script Work" (Figure 1).

Wang Xianzhi (344–388), the seventh son of Wang Xizhi, learned the art of calligraphy as a boy from his father. He inherited his father's techniques, but added to his own creative arrangement and writing style. Wang Xianzhi was skilled at all types of scripts, but particularly running script and cursive script. His pieces show much freedom in form, the brush lines are graceful and elegant and the colors of the ink change from time to time, adding verve of freedom and originality to his works. Wang's calligraphy was a great contribution to the Chinese tradition of artistic romanticism. His most known works are *Yatouwan Tie* and *Mid-Autumn Letter*.

In addition to the family of calligraphers of Wang Xizhi, the Wei and Jin dynasties witnessed other calligraphers such as the brothers Xie (Xie An and Xie Wan), the Wei's (Wei Guan and Wei Heng), the Yu's and the Qie's. It is an exceptional phenomenon in the history of Chinese calligraphy that a great number of calligraphers emerged in one period, which was an indication that the development of Chinese calligraphic art reached a zenith of self-conscious creation. Since then, the particular form of art entered an era of splendor due to the distinctive personalities of the writers.

Beauty of Dignity: The Sui (581–618) and Tang Dynasties

The Sui Dynasty lasted only 37 years, but Sui calligraphers immortalized the dynasty in Chinese history with two masterpieces of standard script: *The Tablet of Longzang Temple* and *Tombstone-Record of Beauty Tong*. The former is known for its lordliness, while the latter, though with very small characters, for its sense of space and rhythm. The two made themselves the basis on which standard script prospered in the coming period, the Tang Dynasty.

As one of the most powerful and prosperous periods in Chinese history, the Tang Dynasty not only gave rise to economic growth and political integrity, but to cultural and artistic renaissance. The development of calligraphic artistic styles experienced three different periods of the dynasty: the beginning years, the prosperous years, and the declining years.

The dynamic calligraphic development in the beginning years of the dynasty owed its great vitality to the second Emperor Li Shimin (599–649). The emperor himself held Wang Xizhi in high esteem for his emphasis on the beauty of ease and freedom, a tradition of the Jin Dynasty, and naturalness and fullness in writing technique. As a result of encouragement and promotion from the imperial authorities, many masters with different styles emerged, including standard script calligraphers Ouyang Xun, Yu Shinan, Yan Zhenqing, and running script calligraphers Zhang Xu and Huai Su. Their works represent a peak in the art of Chinese brushing writing.

Ouyang Xun (557–641), an imperial scholar and calligrapher of the early Tang Dynasty, summarized the features of his own standard script style, known as Ouyang style after his name, as follows: "My ultimate purpose is a neat script balanced on all sides of a character and moderate thickness and length of a stroke." *Inscription on the Sweet Wine Spring in the Jiucheng Palace*, his magnum opus, demonstrates his philosophy reflected in his powerful style of writing (Figure 4: *Inscription on the Sweet Wine Spring in the Jiucheng Palace*).

Yu Shinan (558–638), one of the most famous standard script calligraphers of the early Tang Dynasty, imitated, in his early years of calligraphic career, the artifacts of Wang Xizhi and his son Wang Xianzhi. Structural broadness and elegant skills are features of his works, among which *Stele in Temple of Confucius* is the most famous (Figure 5: *Stele in Temple of Confucius*).

As the Tang Dynasty entered its period of peace and prosperity, calligraphy benefited and differing varieties emerged, which were found in running-cursive and

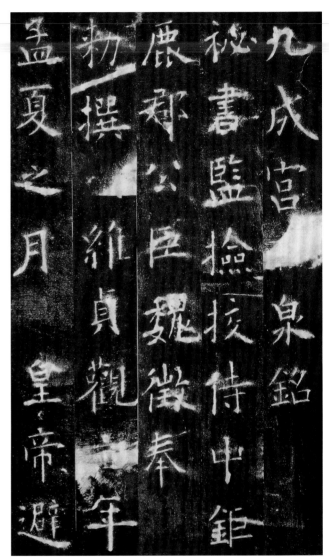

Figure 4

standard scripts. The great calligraphers at the time included Zhang Xu, Huai Su, Yan Zhenqing.

Zhang Xu (675–750) was a cursive script calligrapher known for defying petty conventions. Legend has it that he was different from other calligraphers in that he was excessively fond of drinking and wrote as if with a magic brush to perform his art when he was half-drunk.

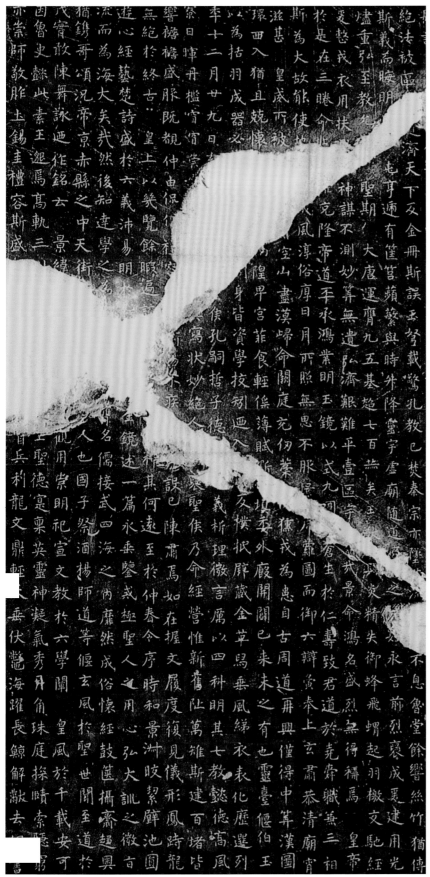

Figure 5

In addition, he claimed that he had got the idea of his style by watching the solo performance of a famous sword-dancer. His style is known for being unconventional and unrestrained, as well as for its spirit of rhythmic dance in his works.

Huai Su (725–785), another cursive script calligrapher, practiced calligraphy after he became a monk in his childhood. He reached national fame at the age of 30. Different from Zhang Xu's works, those by Huai Su, with characters in picturesque disorder of different sizes and graceful lines of strokes, display a beauty of dignity and harmony. *Autobiography* is among the most well-known of Huai's cursive script works.

In conclusion, the progress of calligraphic art made in standard script in the Sui and Tang dynasties is unprecedented. This has something to do with the progressive attitude and open-mindedness of the calligraphers, who established the aesthetic principle of rigorousness and power, which served as the basis from which contemporary Chinese characters have developed.

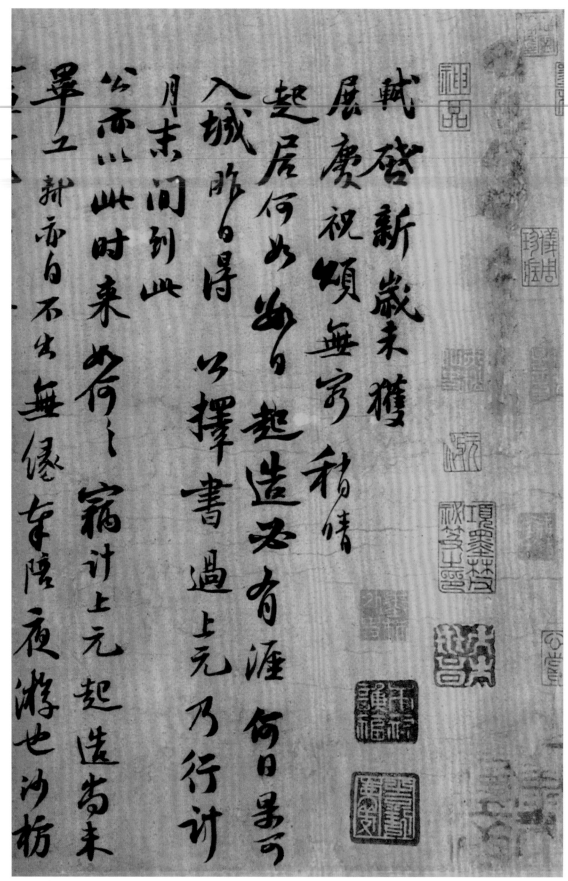

Figure 6

Beauty of Change: The Song, Ming and Qing Dynasties (960–1911)

During the eighty plus years from the Tang Dynasty to the first years of the Song Dynasty, due to the instability of the society, progress in calligraphy ceased and even retrogressed. Only one calligrapher, Yang Ningshi (875–954), left his name in the history of Chinese calligraphy, whose *Jiuhua Tie*, a running-standard script piece, has been acknowledged as a work which serves as a bridge between his predecessors and successors.

While the Song Dynasty (960–1279) as a whole was no match in national strength for the previous period, the Tang Dynasty, a group of intellectual elites who shared similar interests involved themselves in literary and artistic activities, contributing greatly to the fields of literature, drawing and calligraphy. Among them were Su Shi (1037–1101), Huang Tingjian (1045–1105) and Mi Fu (1051–1107) of the Northern Song Dynasty (960–1127) and Lu You (1125–1210) and Zhu Xi (1130–1200) of the Southern Song (1127–1279). What these masters shared with respect to calligraphy was that they all focused on the running-cursive script, stressing the function of calligraphy as a tool to express individual affections and interests (Figure 6: *Xinsui Zhanqing Tie* by Su Shi, Figure 7: *Xin'en Tie* by Mi Fu).

Following the Song Dynasty, several dynasties were established by the minorities from the northern China whose mother tongues were not Chinese and, as a result, calligraphy as an art of Chinese characters languished until Zhao Mengfu (1254–1322), a well-

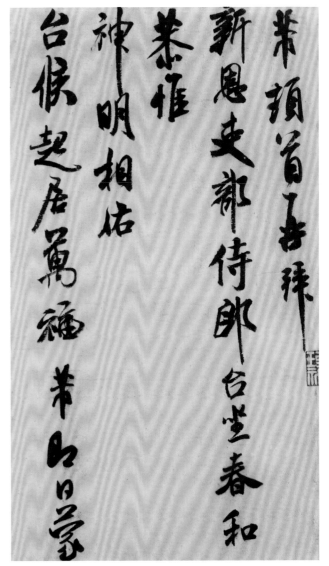

Figure 7

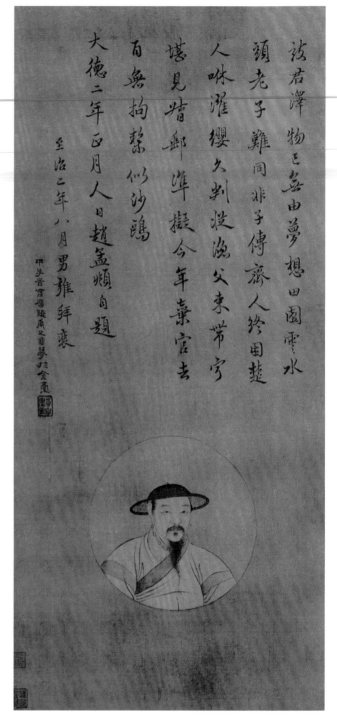

Figure 8

known calligrapher of the Yuan Dynasty (1279–1368). As a descendant of the royal family of the Song Dynasty, Zhao led a monastic life in southern China. Zhao carried forward the style of "freedom and elegance" from Wang Xizhi and his son Wang Xianzhi. His running-cursive script are most impressive (Figure 8: A piece by Zhao Mengfu).

In the Ming Dynasty (1368–1644), a unified dynasty after the turmoil of the previous dynasty, the social and economic prosperity added much diversity and individualization to the art of calligraphy. Most Ming calligraphers were painters as well and, as a result, they borrowed heavily between the two fields in form as well as in technique. Especially in the middle and late years of the dynasty, a large number of calligrapher-painters, such as Dong Qichang (1555–1636), Xu Wei (1521–1593) and Wang Duo (1592–1652), in the part of southern China around Suzhou, came to national fame. As calligraphers, they all emphasized the beauty of the form in their scripts and the variation in brushing, structure and ink color, creating a dominant visual appeal (Figure 9: *An Autumn Landscape* by Dong Qichang).

The Qing Dynasty, the last Chinese feudal dynasty, can never be mentioned in the same breath with the "Time of Tang Prosperity" of over 1,000 years ago. Generally speaking, Qing calligraphers idolized and imitated their predecessors. The early Qing calligraphers, with Fu Shan (1607–1684) and Zhu Da (1626–1705) as their representatives, were greatly influenced by their Yuan and Ming predecessors Zhao Mengfu and Dong Qichang and, consequently, works by past well-known masters were examined and imitated. As archaeology arose as an area of interest

in the late Qing Dynasty, intellectuals showed great interest in collecting antiques, including artifacts of oracle bone script, bronze script, and stone inscriptions. This resulted in the rise of a study on stone inscriptions

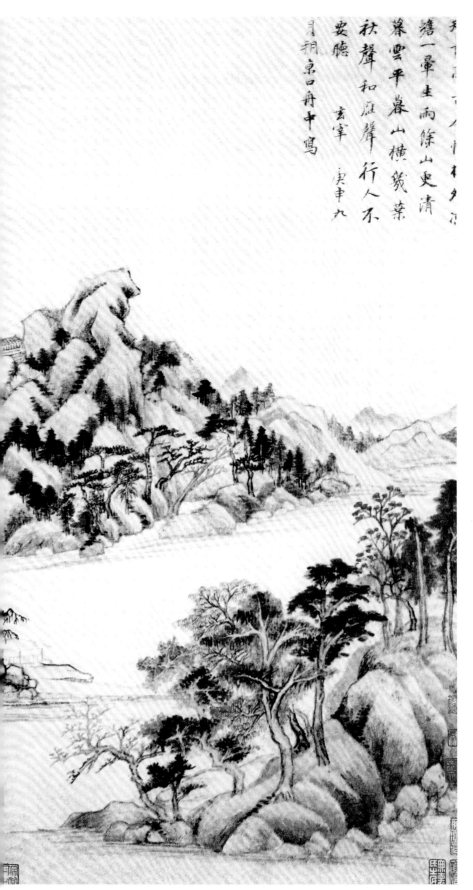

Figure 9

and books of rubbings from stone tablets or bronze vessels and this, in turn, bore significantly on their own works. These calligraphers include, among others, He Shaoji (1799–1873) and Zhao Zhiqian (1829–1884) and the three of their successors, Wu Changshuo (1844–1927), Shen Zengzhi (1850–1922), and Kang Youwei (1858–1927), academically active after the feudal government was overthrown.

To sum up, the Chinese calligraphy as a form of art still developed after its height in the Tang Dynasty. While drawing from the large amount of works left by their predecessors, calligraphers after the Song Dynasty also reformed the traditional art, and efforts were especially made to add formal appeals to cursive script and running script. Reformation was a hard process, but what awaited them was a bright future.

The history of Chinese calligraphy is not only a history of Chinese writing and scripts, but also a record of how Chinese artistic spirit has been enriched and improved. What is seen in the huge number of the calligraphic works is not only an art of the strokes, but the characters and spirits of a great people.

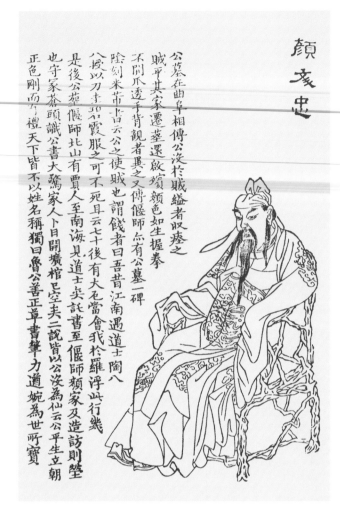

Figure 10

Tang Dynasty Standard Script and Yan Zhenqing's *Qinli Stele*

Kaishu is also called *Zhenshu* (true script) or *Zhengshu* (standard script), meaning it is "straight, rather than curvy." The major contribution of standard script, as a "freeze-framed" form of writing style, to Chinese calligraphy lies in its fixed rules of writing, that is, standardization in the stroke, the order of strokes, and the writing format. Originated in the Eastern Han Dynasty, standard script evolved to its current form in the 5th century during the Southern and Northern Dynasties before enjoying its popularity in the Tang Dynasty. Tang standard script was a witness to the prosperity of the period and it has been a model style that later calligraphers have imitated. The "Eight Principles of Yong" and Ouyang Xun's "Thirty-six Principles," proposed and promoted in the Tang Dynasty, have become the standard style and model of standard script, the most popular style of Chinese calligraphic writing.

Yan Zhenqing was born in Xi'an of Shaanxi Province to a reputed academic family, whose members were all intellectuals of integrity and high moral standards, including several well-known educationalists and calligraphers. Yan himself was a loyal servant of the court. He was sent out of the capital as the governor of Pingyuan, Shandong Province. As an honest and self-disciplined governor who focused on the economic growth and the well-being of the local people, Yan won great respect of the Emperor and his people. At the crucial moment when his country was to be split, he refused to surrender and was killed, becoming a national hero (Figure 10: Yan Zhenqing).

Yan was not only a respected statesman, but also a well-known calligrapher who was always seeking innovation and reform in his field. As a boy, he was found to be exceptionally bright and fond of calligraphy. Legend had it that he practiced writing with yellow earth on the wall as a boy due to lack of paper and ink. He was recognized as a good calligrapher at the age of thirty. Then he studied calligraphic techniques under the famous calligrapher Zhang Xu, who was skilled in cursive script and, as a result, Yan made qualitative breakthroughs in writing techniques. His techniques and skills matured when he was about 45. He wrote one of his best-known pieces, *Duobao Pagoda Stele*, at the age of 44, and about two years later another piece,

18

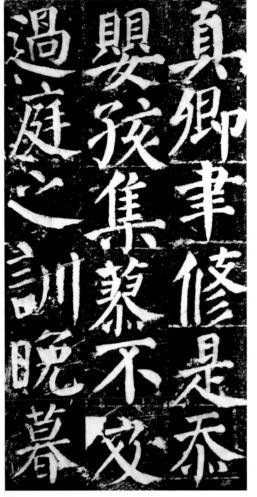

Figure 11

Ode to Dongfang Shuo. The *Draft of the Eulogy for My Nephew* and *Letter on the Controversy over Seating Protocol* were both written when he was around fifty. Like many others, Yan became a master calligrapher as he advanced in age, and his best-known pieces were written when he was over seventy, including *Qinli Stele* (at the age of 71) and *Yanjia Miao Stele* (at the age of 72). With years of continued efforts and his quick comprehension of the skills and powers in the works of his predecessors, Yan secured for himself a spot in the sphere of calligraphy in the Tang Dynasty as well as in the history of Chinese calligraphy. With his own genre, "Yan style," among all the kinds of standard script, features natural skills, changeable strokes, and impressive power. Yan style has been a classic model for calligraphers to imitate.

Qinli Stele was a gravestone Yan Zhenqing inscribed for his great grandfather, Yan Qinli, at the age of 71. The stele, erected in about 779 and unearthed in 1922 in the city of Xi'an, Shaanxi Province, is the best preserved stele of Yan's and is on permanent display in Xi'an Bei Lin Museum. The stele has 44 lines on the four sides, containing 1,667 characters. It was found split in the middle when unearthed, but the characters on it were not seriously damaged. This stele has been often copied by calligraphy beginners.

The style of Yan, as displayed in *Qinli Stele*, is evaluated mainly with respect to brushing, composure and the style as a whole. First, Yan's standard script was written with a medium-tipped brush; the horizontal stokes were done with less force and as such were thinner than the vertical ones, which were written with more force. The forceful rising or pausing movement can be easily seen at the turning point of a stroke, producing a sense of balance between what is firm and what is plump. For character structure, Yan style displays squared shape, with spacious center portion. Single-radical characters, such as 工 , 之 , and 心 , were finished with a dominant stroke, being well-balanced and well-structured. At the same time, the great number of characters with two or more radicals, including top-bottom characters such as 著 and 泉 , left-right characters such as 海 , 加 and 侍 , and more structurally complicated ones such has 觀 , 鶴 and 監 , were written with great attention on the balance between the top and bottom strokes or the left and right strokes, creating proper spaces between stokes and structural harmony as a whole. In addition, *Qinli Stele* was also remembered for Yan's own genre of calligraphic vigor and power, which displayed his own personality as well as the High Tang spirits. It also defined a new aesthetic standard that went against the "beauty" of euphemism and femininity once appeared after Wei and Jin dynasties (Figure 11: Part of *Qinli Stele*).

The sample characters against the black background in the "exercise" come from *Qinli Stele*.

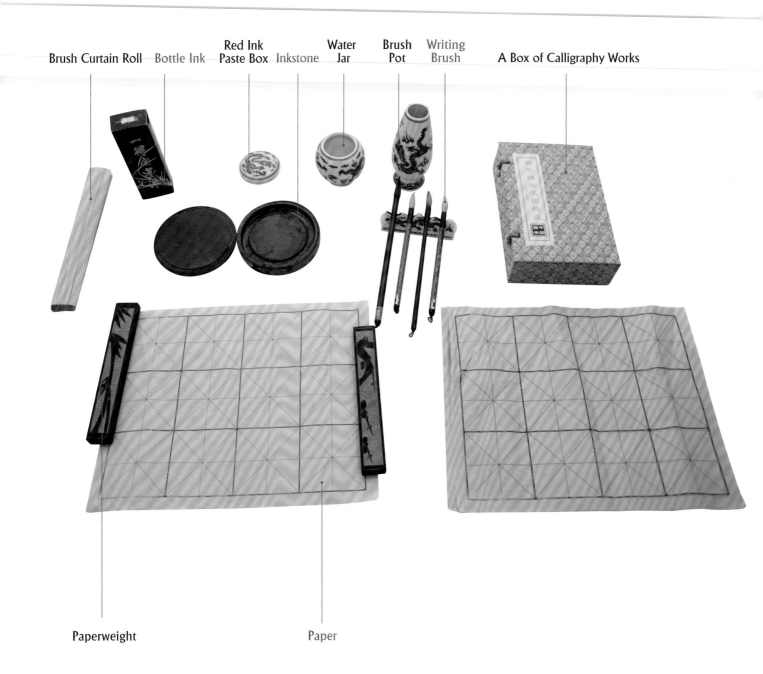

Brush Curtain Roll Bottle Ink Red Ink Paste Box Inkstone Water Jar Brush Pot Writing Brush A Box of Calligraphy Works

Paperweight Paper

Figure 12

Preparation for Writing *Kaishu*

Four Treasures of Calligraphy Study

Among the various tools of calligraphy, the "Four Treasures of Calligraphy Study"—writing brush, ink-stick, paper and inkstone—are household words in China. With a history of several thousand years, they are not only the tools for calligraphers, but also items to treasure. Calligraphy beginners, therefore, need to learn the basics of the four treasures and characteristics of each to make best use of them when writing (Figure 12).

Writing Brush

The writing brush is the most important of the "Four Treasures of Calligraphy Study." Although it has a long history that can be traced back to Qin Dynasty in the 3rd century BC, its structure and function have remained the same, while the craft of brush-making has been improved from time to time. The writing brush has a shaft and a tip, with the latter as the key on the basis of which brushes are classified into different categories. First, the types of hair of the tip result in three categories: *yinghao* (hard), *ruanhao* (soft) and *jianhao* (mixed). According to

the size of the tip, brushes are generally classified as either *dakai* (big), *zhongkai* (medium) or *xiaokai* (small). On the basis of the length of the tip, they are also classified into three types: the *changfeng* (long-tipped), *zhongfeng* (medium-tipped) and *duanfeng* (short-tipped). Calligraphy beginners will find the medium-tipped mixed hair brush the easiest to handle and as they make progress, they may try the soft brush with a longer tip.

A good brush features a sharp end, even hair, and a well-rounded and elastic tip. In addition, good maintainance helps a brush last longer. For proper maintenance, a brush must be well-soaked before use, it must never be over-dipped into the ink, and it must be washed thoroughly each time after use.

Ink-Stick

The ink has a longer history than the brush. People in the Xizhou Period (12th century BC) were reported to write and draw with blocks of natural black earth. This can be easily seen from the structure of the Chinese character for "ink-stick" (墨), a word "black"(黑) on top of "earth" (土). While the earliest ink was made from natural graphite among other natural materials, man-made ink,

usually a mixture of different materials, was developed later.

Traditionally, the ink came in sticks that would be rubbed with water on an inkstone until the right consistency was achieved. While this was a step necessary for writers in earlier times, it was inconvenient for them. In particular, when they were composing long pieces, to prepare the ink was time—and energy—consuming, which might have interfered with the writing process, as well as the writer's inspiration. Most calligraphers now use pre-mixed bottled inks, which saves the trouble and the time of rubbing the stick. The ink stick and the inkstone are now found among the works of art for appreciation and often used for decorative purposes.

Paper

Among the "Four Great Inventions"—the compass, gunpowder, paper-making, and printing, the paper-making technology has contributed greatly to the development of Chinese characters and Chinese culture. Before paper was invented, scratches were made on animal bones, bronze wares, stones, and bamboos. In the Western Han Dynasty in the 2nd century BC, efforts were made to make paper from hemp. It was not until the middle of the Eastern Han Dynasty (105) that Cai Lun greatly upgraded the paper-making techniques, resulting in quality paper that could be used for practical purpose, and a significant improvement in the range to and the speed at which writing was spreading. Among the many types of paper available today, *Xuanzhi* (*Xuan* paper, named after the place of production), traditionally made in Xuancheng, Anhui Province, is the best known.

Different categories of *Xuanzhi* are chosen for different styles of writing or painting. Generally speaking, *Xuanzhi* has better absorbency and is used when writing bigger Chinese characters. Paper with a thin layer of alumina on surface is used when writing small characters because ink does not permeate easily. Even newspapers can be used as an alternative for beginners.

Inkstone

The inkstone, made from earth, stone or other materials, is used to rub the solid ink stick into liquid ink and to contain the ink once it is liquid. It is also a writing tool on which calligraphers prepare the tip of the brush from time to time. While inkstones are made from different materials and are of different types, *Duanyan* (*Duan* inkstone) and *Xiyan* (*Xi* inkstone), named after the homes of the stones in which they are made (Duanxi, Zhaoqing City in Guangdong Province and Xi County in Anhui Province) are the top two among calligraphers.

Just as contemporary writers prefer the pre-mixed bottled ink to the solid ink stick, the color mixing tray has replaced the inkstone on the desk of calligraphers. However, as one of the "Four Treasures" for brush writing, inkstones are always found in the elegant study of a calligrapher.

Writing Postures

In China, Calligraphy is not only considered an important means of achieving artistic cultivation, but also an active way to help practitioners keep fit and build endurance, an exercise believed to be as healthy as *tai chi*. Therefore, practitioners are advised to follow the suggested instructions regarding writing postures and brush holding.

Body Postures

Calligraphy should be done while seated or standing.

For sitting posture, the position of the head, body, arms and feet is important as it affects the writing quality. Generally speaking, the body needs to be as relaxed as possible and all the parts must work as a "team." The head should be held straight, so you have a better view of the spot on which you intend to write. With your head aslant, you may produce characters that are not so

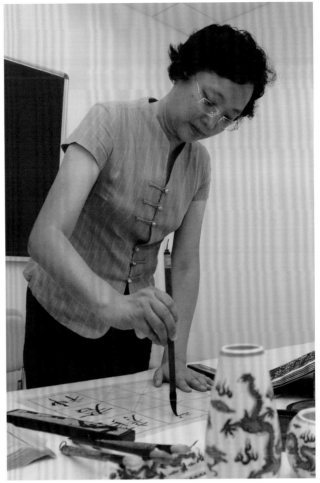

Figure 14

neat and regular. The upper body should be erect, the shoulders relaxed and balanced, and the chest kept a fist's width away from the desk. With the two arms slightly apart, the writing hand holds the brush, while the paper is held down by the other hand. The feet are evenly apart and relaxed on the ground (Figure 13). With all these parts in harmony and relaxation, the writer needs to concentrate on the writing hand, which will ensure the smoothness of each stroke, instead of paying undue attention to the posture.

More experienced writers often stand while writing, a posture which is also assumed to write larger characters. On the basis of the place on which characters are intended, standing postures are of three types. The first position is assumed for writing at a desk by suspending

Figure 13

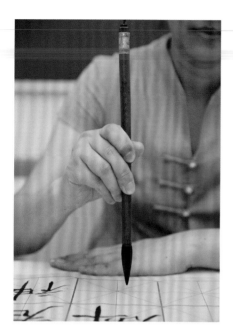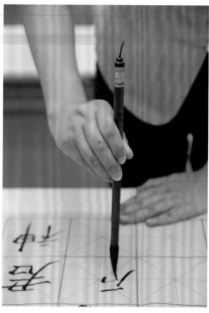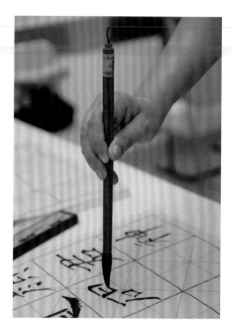

Figure 15

the arm in the air, while lowering the upper body and facing down on the paper (Figure 14). Another posture is adopted when writing on a wall or a board about the height of the body, with the arm naturally extending to reach the spot and the eyes looking straight ahead or up. For writing extra large characters, the third posture, different from the previous two, is a dynamic one and the writer works while moving, with the hands holding a special brush and bending forward.

Ways of Holding the Brush

The way to hold the writing brush has been a controversial issue and heatedly debated, and many calligraphers disagree. A popular manner is called "thumb-fingers method," which requires a coordinated force of the four fingers and the thumb, resulting in balanced and exact movements. In addition, the palm, wrist, elbow, and even the upper body also help with the method. The palm is held in the manner as if you were holding an egg and right above the paper (Figure 15). The wrist and the forearm are kept parallel, while working, to the paper. When larger characters are intended for, the wrist and the forearm need to be suspended so as to coordinate the forces from the finger, the thumb, the palm, the elbow, and the arm, which produces more forceful writing. Furthermore, the position of holding the brush depends on the style intended. When you are writing standard script, you need to hold the lower part of the shaft—an easier way to handle and move the brush steadily. Holding the upper part of the shaft enables you, when writing the cursive script or the running script, to move your fingers and thumb more nimbly and quickly.

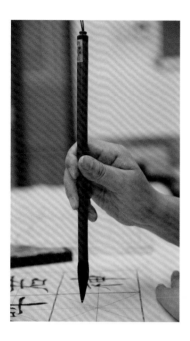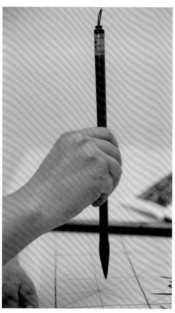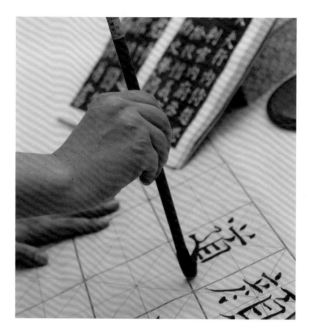

Figure 15

In addition to the "thumb-fingers method," there are some other ways of holding the brush, such as "four-finger method" and "three-finger method." With the increasing proficiency in writing, many calligraphers adjust their ways of holding the brush based on their creative needs, which varies from person to person. In any case, standard postures and the cultivation of good writing habits are absolutely necessary for beginners.

The Mood

Calligraphy writing, among other forms of art, is an advanced display of human thinking; the mood at writing affects the results. As Yu Shinan, a well-known calligrapher in the Tang Dynasty, observed in his *Writing*
Essentials, "When starting to brush, calligraphers must shut themselves up from the outside world and be free from worries. They must concentrate on what they are doing and be in a good mood. An anxious and distracted writer produces unbalanced irregular scripts, while a bad mood results in derivation from the tradition." Therefore, moods affect the representation of the writing and different styles require different moods.

The standard script is a good starting point for beginners. Before attempting to write, the writer must be completely relaxed and even-tempered. While writing, disturbance should be avoided and the writer needs to concentrate on his or her work, creating the best psychological and physical environments. With enough patience and dedication, every practitioner has the power to become a good calligrapher.

25

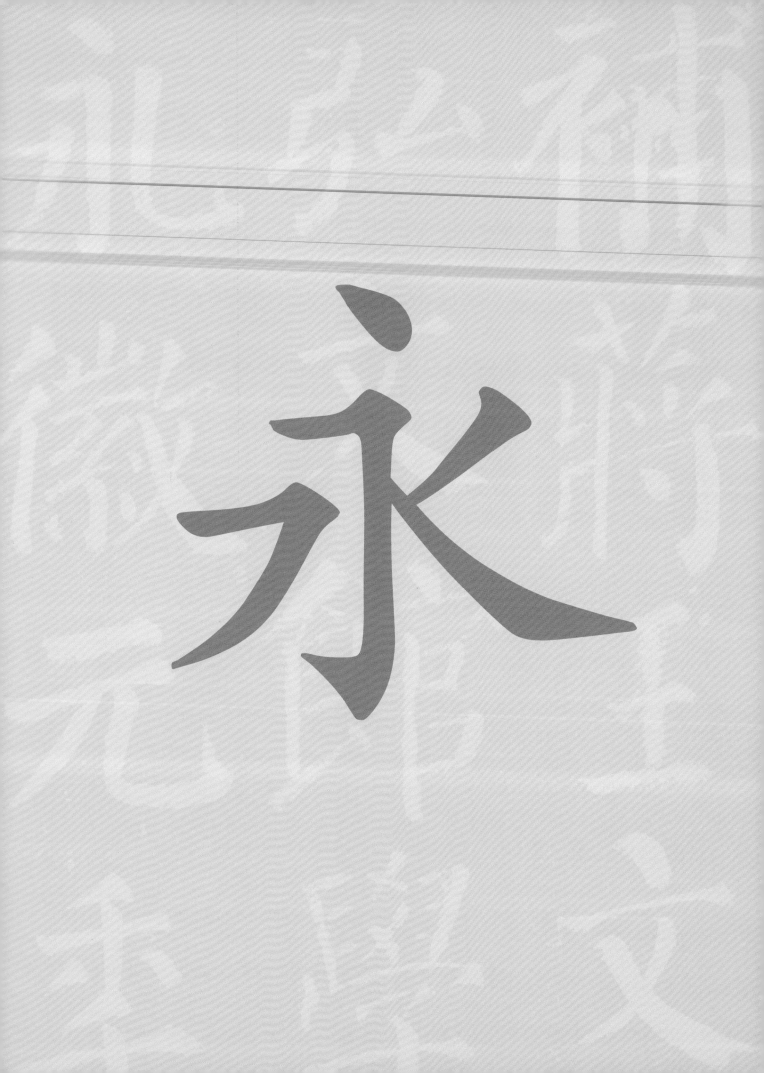

Introducing the Basic Strokes

Eight Principles of the Character *Yong*

The Eight Principles of the Character *Yong* explains how to write the eight common strokes in Chinese characters found all in the character of *yong* (永 , meaning "permanence"). They are considered the basis of Chinese standard script strokes.

1. Dot (*Ce or Dian*)

Go right immediately after the tip of the brush touches the paper, and then go down a bit with increasing force before an upward finish (*cangfeng*).

2. Horizontal Stroke (*Le or Heng*)

Go right immediately after the tip of the brush touches the paper, which is followed by a short horizontal bar before you finish.

3. Vertical Stroke (*Nu or Shu*)

Start where you have finished the previous horizontal stroke, and then go downward for a vertical line, but with a short and slight left turn.

4. Hooked Stroke (*Li or Gou*)

Press Down (*dunbi*)[2] as you finish the previous vertical stroke, *nu*, and then finish with a short and upward hook.

5. Rising Stroke (*Ce or Ti*)

Go right with force immediately after the tip of the brush touches the paper, and then move toward upper right to finish the stroke. Make sure that the stroke is thinning as you go.

6. Long Down Stroke to the Left (*Lue* or *Pie*)

Make a tapering line toward lower left, a stroke which is written in a quick and forceful manner.

7. Short Down Stroke to the Left (*Zhuo* or *Duan Pie*)

Draw a short tapering line with a forceful start, but thinning toward lower left.

8. Down Stroke to the Right (*Zhe* or *Na*)

Draw a thickening line toward lower right, finishing with a downward force and followed by a very short thinning horizontal stroke.

Special Terminology and Tips for Using the Brush

The special terms for the strokes are divided into three steps: the beginning of the stroke, the continuation of the stroke, and the finishing of the stroke.

Beginning the Stroke

• *Luobi*: The first touch of the brush on the paper, which locates a stroke and prepares the writer for the next movement.

• *Cangfeng*: A skill with which the writer "hides" the first touch of the brush in a stroke, starting to write in the direction opposite to the one intended: moving the brush a bit to the left first when a right-to-left stoke is intended or moving it upward a bit when you are to write a downward stroke. Make sure that the opposite movement should be short and slight and can never be overdone; otherwise, the first touch would be ill-formed.

• *Shunfeng*: A way to wield the brush after *luobi* or, specifically, with the tip of the brush pointing to the direction opposite to the intended movement, pause a bit after *luobi* to allow the ink to permeate, before continuing with the middle section of the brush.

• *Qiangfeng*: A turning or revolving movement of the brush before touching on the paper, which is usually used in writing the first stroke of a character or during a short pause between strokes, serving as a void connection in writing.

Continuing the Stroke

• **_Xingbi_**: A way to wield the brush on paper, without stopping, from one place to another. All strokes are results of _xingbi_.

• **_Zhubi_**: A pause between writing different strokes. It is a slight movement between ticking and pressing with the brush, which requires skillful controls over the fingers and the wrist.

• **_Dun_**(顿)**_bi_**[1]: A skill to press the brush with force to allow the ink to permeate, as if you were hammering a nail into the wall or forcing the brush through the paper. While pressing, a slight ticking movement is needed for a second pressing action. The combination of ticking and pressing helps with the progress of the brush, while producing a firm stroke.

• **_Dun_**(蹲)**_bi_**[2]: A similar skill to the previous one, _dunbi_[1], but slighter in force to allow a slower permeating of the ink into the paper. While _dunbi_[1] resulting in local thicker part of a stroke, _dunbi_[2] helps with the thickness of the whole of a longer stroke. Standard script requires, by and large, a moderate thickness of the stroke and strokes should not be overdone or underdone.

• **_Tibi_**: A slight ticking, without lifting the tip of the brush away from the paper, after _dunbi_[1], _dunbi_[2], or _zhubi_ and before the next movement. This skill is also used for long and thick strokes. Make sure that while a ticking is being made, the tip of the brush touches the paper so that the ink permeates smoothly and evenly to produce a thin but real stroke. An incorrect writing speed or a wrong angle between the tip of the brush and the paper will result in broken or dotted stroke.

• **_Cuobi_**: A change in direction of the tip of the brush and away from the original place after _tibi_. In standard script writing, the skill is normally used at the turning point to avoid a round turn. It is also used to brush a _gou_ (hooked stroke) or _na_ (down stroke to the right) to add a sense of thickness to the position of hook or the direction of the pressing.

• **_Nvbi_**: A backward move of the tip of the brush after _cuobi_. The skill is used to avoid stroke being too smooth and add variation to it, creating an impression of firmness and vigor.

• **_Tuobi_**: A way to spread the tip of the brush to the two sides after _dunbi_[1] so as to produce a thicker stroke.

Finishing the Stroke

• **_Huifeng_**: A backward movement of the brush along the inner or outer line when finishing a stroke. This skill is used for all strokes in standard script, except for those with a sharp tip.

• **_Zongbi_**: A movement to finish a stroke, letting the tip of the brush go without a backward movement.

• **_Kongshou_**: A quick backward movement of the brush at the end of a stroke, after the tip of the brush is away from the paper.

Exercises

Basic Strokes

一 (yī) **one**

二 (èr) **two**

Horizontal Stroke

一 二

•**Diagram of the strokes with explanations**

(1) Start in the opposite direction;

(2) Turn downward with a press;

(3) Tick upward to the central position of the intended stroke;

(4) Go right in a seemingly unsmoothed manner;

(5) Tick up a bit;

(6) *Dunbi*[1] (Press Down) in the lower right-hand direction, as a dot is intended;

(7) Lift the brush again and then slight *dunbi*[1](Press Down);

(8) Finish with a *huifeng* (a slight backward movement).

工 (gōng) **work**

Horizontal Stroke with a Left Point

工 王

•Diagram of the strokes with explanations

(1) Start with the middle section of the brush, and then go in the higher right-hand direction;

(2) Press with more force while wielding the brush;

(3) *Dunbi*[1] (Press Down);

(4) *Dunbi*[2] (Press Down slightly slowly) before lifting the brush a bit;

(5) Finish with the tip of the brush moving backward.

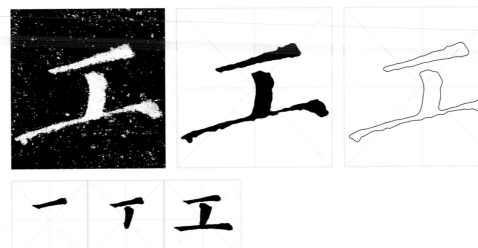

王 (wáng) **king**

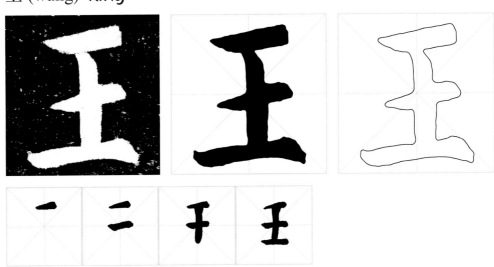

34

早 (zǎo) *early*

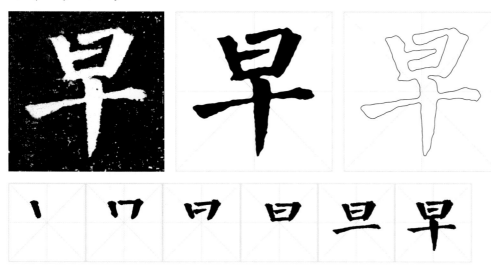

里 (lǐ) *inside*

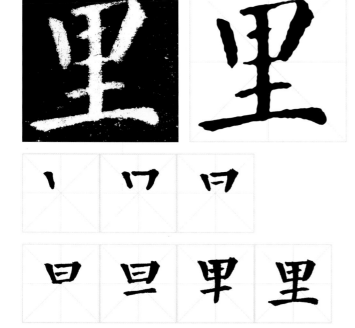

Horizontal
Stroke
with a Right
Point

早　里

**•Diagram of the strokes
with explanations**

(1) Start in the opposite direction;

(2) Turn downward with a *dunbi*[1];

(3) *Cuobi* to the central position of the intended stroke;

(4) Move right while lifting the brush a bit;

(5) Finish at the right end with a *kongshou* to the left.

Vertical Stroke

十 (shí) **ten**

Perpendicular Needle

十　千

• **Diagram of the strokes with explanations**

(1) Start in the opposite direction and turn to the higher left-hand position;

(2) Make a short right-falling *dunbi*[1];

(3) *Cuobi* to the central position of the intended stroke;

(4) Turn with an upward short *dunbi*[1] to get ready for the downward movement;

(5) While going downward, make the brush line a bit wider to both sides;

(6) Pause for a while;

(7) Finish with an upward *kongshou*.

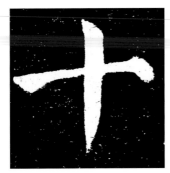

千 (qiān) **thousand**

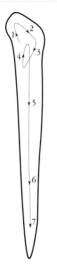

36

川 (chuān) *river, plain*

 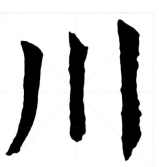

士 (shì) *soldier, scholar*

Drooping Dew

川　士

• Diagram of the strokes with explanations

(1) Start in the opposite direction and turn at the higher left-hand position;

(2) Make a slight right-falling *dunbi*[1];

(3) *Cuobi* to the central position of the intended stroke;

(4) Turn upward slightly to get ready for the downward movement;

(5) Go down firmly;

(6) Make a slight *cuobi* to the left;

(7) Turn to the lower right-hand position;

(8) *Dunbi* and then *tibi*;

(9) Finish with the tip of the brush upward inside the stroke.

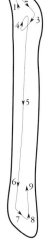

Down Stroke to the Left

Long Down Stroke to the Left

左 在

•**Diagram of the strokes with explanations**

(1) Start in the opposite direction;

(2) Turn and then *dunbi*[1], as if a dot is intended;

(3) Move the tip of the brush to the central position of the intended stroke;

(4) Turn upward to get ready for the left-falling part;

(5) Gradually lift the brush in a seemingly unsmoothed manner;

(6) Pause for a while;

(7) Continue to finish with a sharp tip.

左 (zuǒ) left

在 (zài) on, in

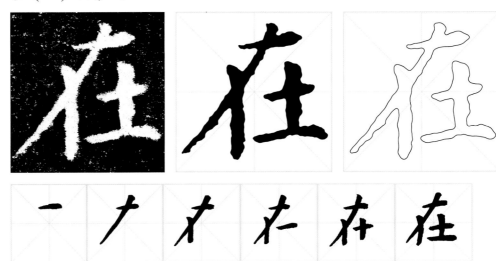

牛 (niú) *cattle*

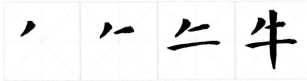

仁 (rén) **benevolence**

Short Down Stroke to the Left

牛　仁

•Diagram of the strokes with explanations

(1) Start in the opposite direction;

(2) *Dunbi*[1], as if a dot is intended;

(3) *Cuobi* to the upper part of the intended stroke;

(4) Turn to get ready for the rest of the stroke;

(5) Write the left-falling part along with the upper outer line;

(6) Continue to finish with a sharp tip.

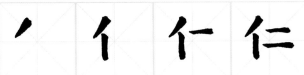

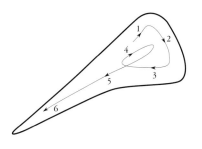

Down Stroke to the Right

Down Stroke to the Right

人 大

人 (rén) *person*

•Diagram of the strokes with explanations

(1) Start in the lower left-hand direction;

(2) Turn upward;

(3) Move to the lower right-hand side, as if looking upward with an increasing force;

(4) *Cuobi* to the central part of the intended stroke;

(5) *Dunbi*[2];

(6) Finish with less force to write the tip part of the stroke.

大 (dà) *big*

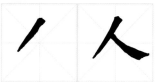

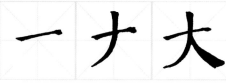

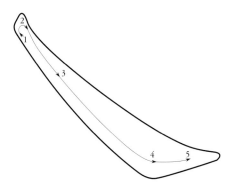

Dot

主 (zhǔ) *master*

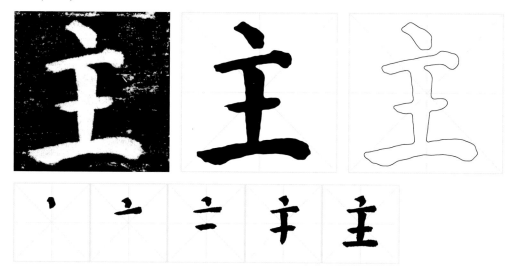

太 (tài) *too*

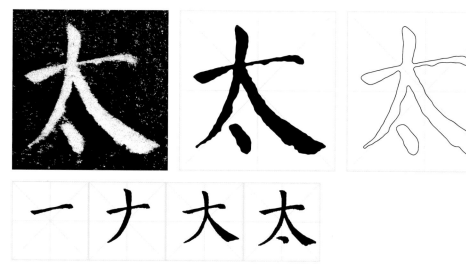

Melon-Seed Dot

主　太

•Diagram of the strokes with explanations

(1) Start with a *cangfeng* skill in the opposite direction;

(2) *Dunbi*[1] in the lower right-hand direction;

(3) *Tuobi*;

(4) *Dunbi*[2];

(5) *Huifeng* in the higher left-hand direction.

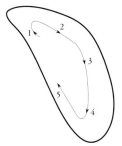

少 (shǎo) **less**

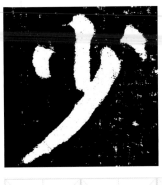 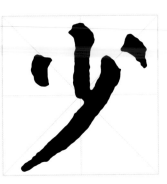

Dot with a Tick

少　江

• **Diagram of the strokes
with explanations**

(1) Start with a *cangfeng*
in the opposite direction;
(2) *Dunbi* in a seemingly
unsmoothed manner;
(3) *Tuobi*;
(4) *Dunbi*[2];
(5) Turn upward;
(6) *Cuobi* to the center
of the dot;
(7) Finish with a lift of
the brush to make the
tick.

江 (jiāng) *river*

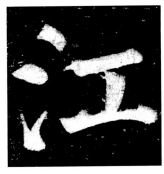 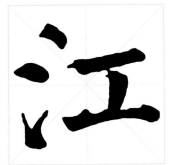

下 (xià) *down*

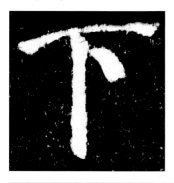
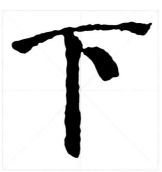
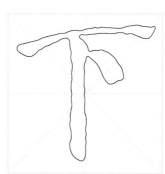

不 (bù) *no, not*

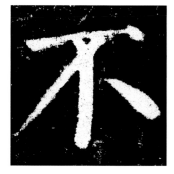
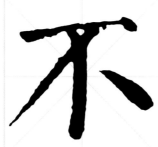
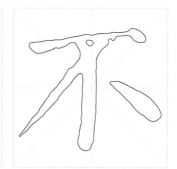

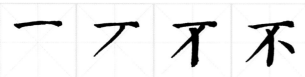

Long Dot

下　不

•Diagram of the strokes with explanations

(1) Start with a *cangfeng* in the opposite direction;
(2) Move in the lower right-hand direction;
(3) *Dunbi*[1];
(4) Make a turn;
(5) Finish with a *huifeng* in the higher left-hand direction.

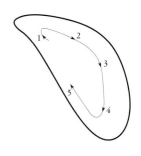

Turning Stroke

日 (rì) **sun**

Horizontal Turning Stroke

日　中

• **Diagram of the strokes with explanations**

(1)–(6) Same as steps (1)–(6) to write a horizontal stroke (refer to p. 33);
(7)–(12) Same as steps (3)–(9) to write a drooping dew (refer to p. 37).

中 (zhōng) **center**

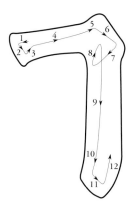

山 (shān) hill, mountain

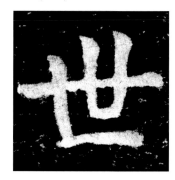
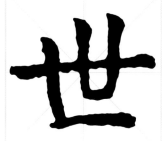
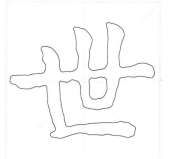

Vertical Turning Stroke

山 世

•Diagram of the strokes with explanations

(1)–(5) Same as the steps (1)–(6) to write a drooping dew (refer to p. 37);

(6) Return to the central position of the vertical stroke;

(7) Go a bit upward as you continue;

(8) Finish with a *huifeng*.

世 (shì) world

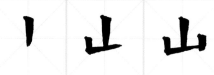

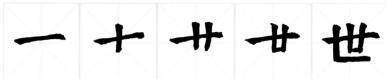

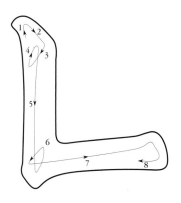

七 (qī) seven

Vertical Curved Turning Stroke

七　四

• Diagram of the strokes with explanations

(1)–(5) Same as the steps (1)–(6) to write a drooping dew (refer to p. 37);

(6) Make the turn by pressing down with thumb forcefully;

(7) Go a little bit upward as you continue;

(8) Pause and finish with a *kongshou*.

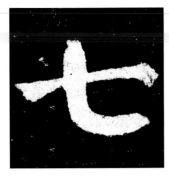
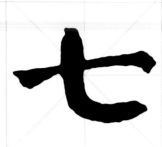

四 (sì) four

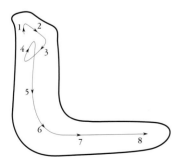

Hooked Stroke

小 (xiǎo) small

才 (cái) just

Vertical Hooked Stroke

小　才

•**Diagram of the strokes with explanations**

(1) Start in the opposite direction;

(2) *Dunbi*[1] in the lower right-hand direction;

(3) *Cuobi* to the central position of the intended stroke;

(4) *Huifeng* upward to get ready for the rest of the stroke;

(5) Go downward with force and somewhat an arc;

(6) Continue with part of an oval;

(7) *Huifeng* upward;

(8) Finish with a hook.

于 (yú) **in**

Curved Hook

于　手

•Diagram of the strokes with explanations

(1) Start in the opposite direction;

(2) *Dunbi*[1] in the lower right-hand direction;

(3) *Cuobi* to the central position of the intended stroke;

(4) *Huifeng* upward to get ready for the rest of the stroke;

(5) Pause and go downward in a seemingly unsmoothed manner, with somewhat an arc;

(6) *Cuobi* to the left;

(7) *Huifeng* upward, and then *dunbi*[2];

(8) Finish with a hook to the left.

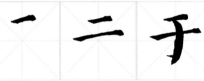

手 (shǒu) **hand**

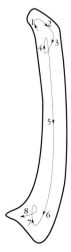

兄 (xiōng) *elder brother*

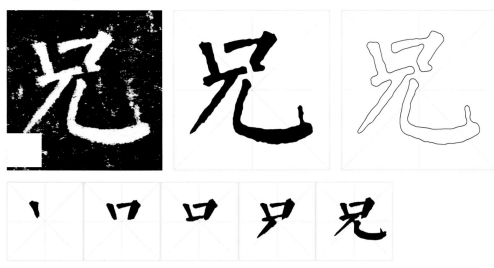

先 (xiān) *first*

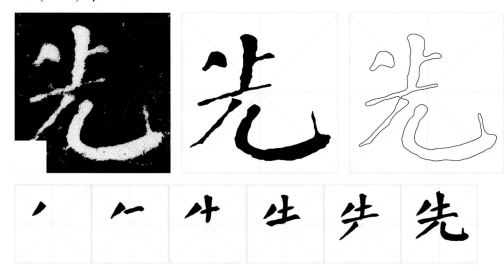

Vertical Turning Hook

兄　先

•**Diagram of the strokes with explanations**

(1)–(5) Same as the steps to write a vertical curved turning stroke (refer to p. 46);

(6) Go a bit upward at the turn, as if with elasticity;

(7) *Dunbi*[2] for an oval shape;

(8) Turn the tip of the brush;

(9) Finish with a hook.

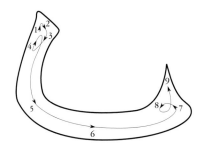

Rising Stroke

功 (gōng) merit

Slanting Rising Stroke

功

•**Diagram of the strokes with explanations**

(1) Start in the opposite direction;

(2) *Cuobi* to the central position of the intended stroke;

(3) Make a turn to get ready for the rest of the stroke;

(4) Lift the brush slowly as you progress;

(5) Finish with a tip.

 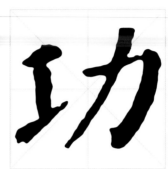 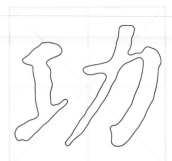

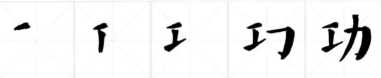

以 (yǐ) with

Vertical Rising Stroke

以

•**Diagram of the strokes with explanations**

(1)–(2) Same as steps (1)–(6) to write a drooping dew (refer to p. 37);

(3) Turn to the lower left-hand position;

(4)–(5) Same as steps (1)–(6) to write a slanting rising stroke.

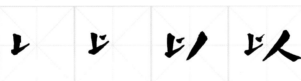

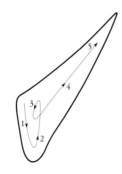

Common Complex Strokes

又 (yòu) again

友 (yǒu) friend

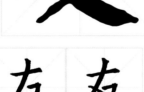

Horizontal Turning Left-Falling Stroke

又　友

•**Diagram of the strokes with explanations**

(1)–(6) Same as steps (1)–(6) to write a horizontal stroke (refer to p. 33);

(7) *Cuobi* to the central position of the intended stroke;

(8) *Huifeng* to get ready for the rest of the stroke;

(9) Go downward tightly in the lower left-handed direction;

(10) Pause for a while;

(11) Finish with the tip of the stroke.

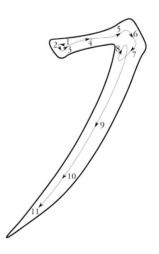

内 (nèi) inside

Horizontal Turning Hooked Stroke

内　司

• **Diagram of the strokes with explanations**

(1)–(2) Same as steps (1)–(4) to write a pointed horizontal stroke (refer to p. 35);

(3)–(4) Same as steps (2)–(4) to write a curved hook (refer to p. 48);

(5) Curve, as going downward, with a greater degree than that of a curved hook and significant elasticity.

(6) *Huifeng* upward and finish with a hook.

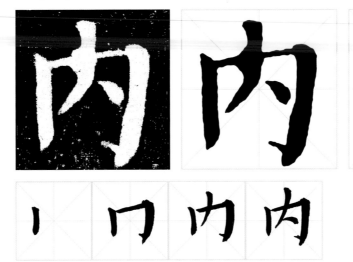

司 (sī) operate

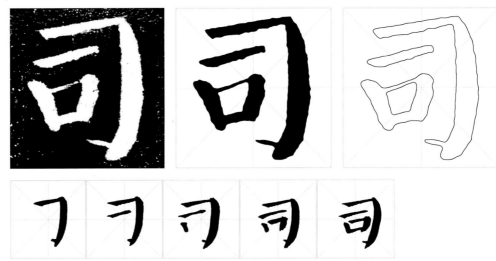

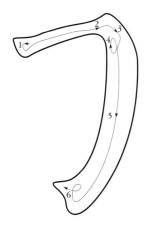

九 (jiǔ) **nine**

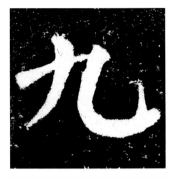

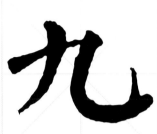

风 (fēng) **wind**

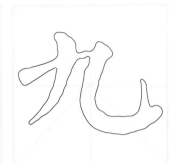

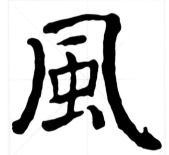

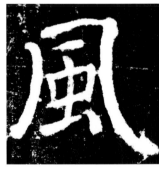

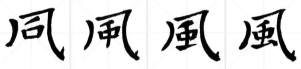

Horizontal Turning Stroke with a Hook

九　风

•Diagram of the strokes with explanations

(1)–(2) Same as steps (1)–(4) to write a horizontal stroke with a right point (refer to p. 35);
(2)–(4) Same as steps (1)–(9) to write a vertical turning hook (refer to p. 49).

Common Chinese Characters

(1) Characters
with the Radical
亻 (dānrénpáng)

仕　作

仕 (shì) **fill an office**

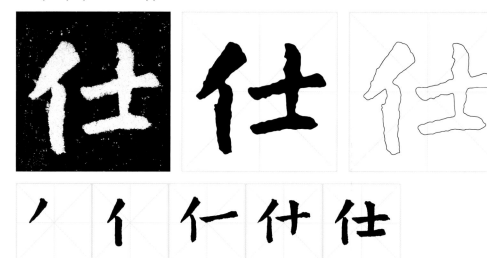

ノ 亻 仁 什 仕

作 (zuò) **do, make**

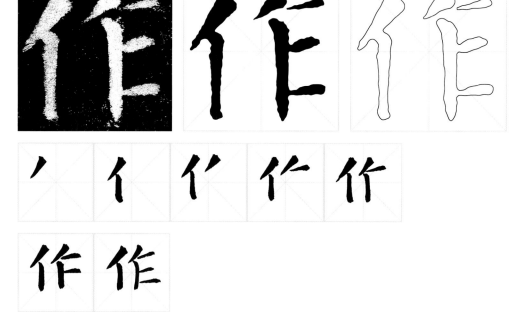

ノ 亻 亻 作 作

作 作

54

介 (jiè) interpose

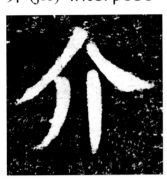 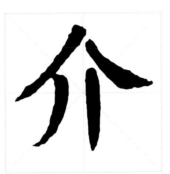

(2) Characters with the Radical 人 at the Top (rénzìtóu)

介　合

合 (hé) total

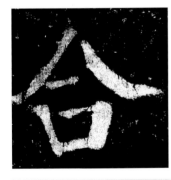 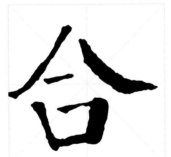

55

(3) Characters with the Radical 力 (lìzìpáng)

幼　加

幼 (yòu) **young**

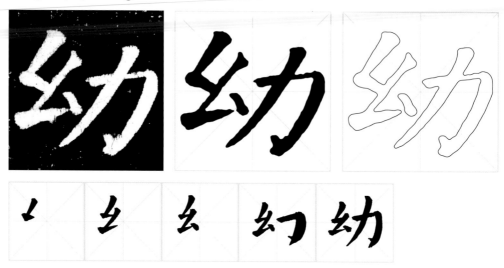

加 (jiā) *add*

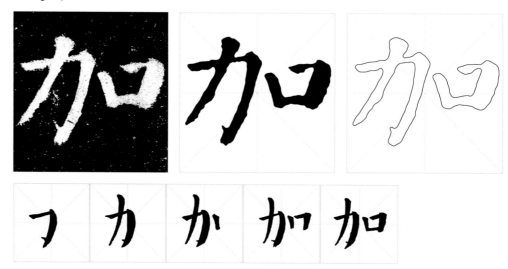

恬 (tián) *tranquil*

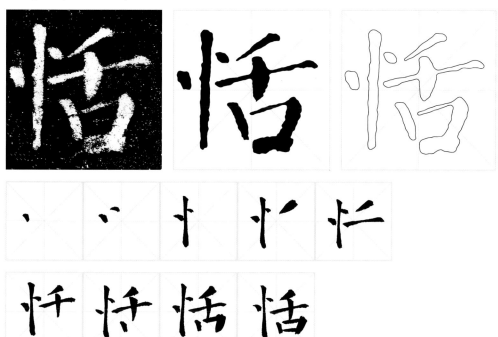

(4) Characters
with the Radical
忄 (shùxinpáng)

恬　怡

怡 (yí) *comfortable*

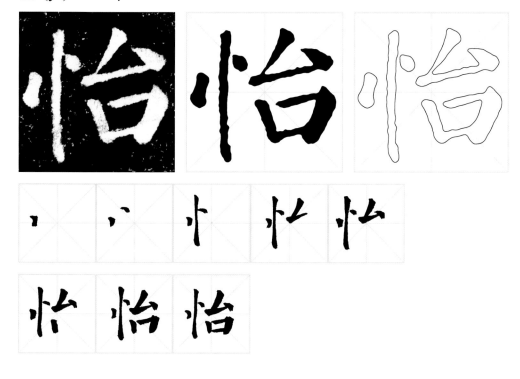

行 (xíng) *walk*

(5) Characters with the Radical 彳 (shuāngrénpáng)

行　得

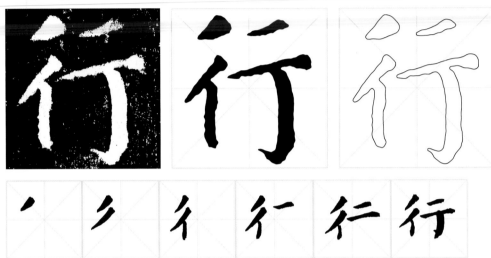

得 (dé) *gain*

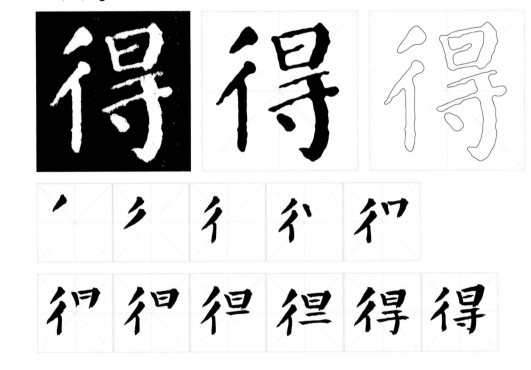

如 (rú) **like**

(6) Characters with the Radical 女 (nǚzìpáng)

如　好

好 (hǎo) *good*

草 (cǎo) *grass*

(7) Characters with the Radical 艹 (cǎozìtóu)

草　英

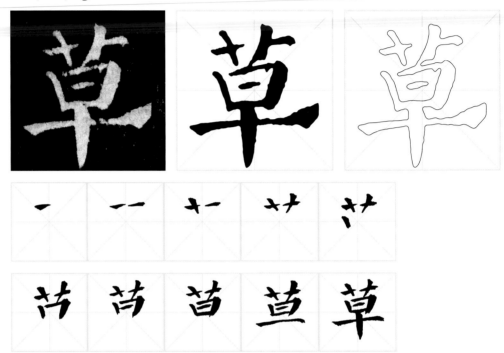

英 (yīng) *hero*

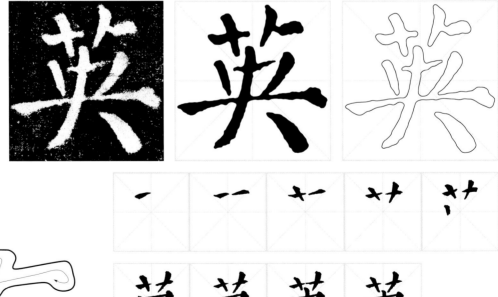

河 (hé) *river*

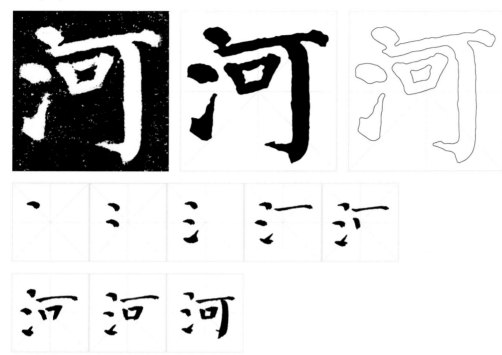

(8) Characters
with the Radical
氵 (sāndiǎnshuǐ)

河　洗

洗 (xǐ) *wash*

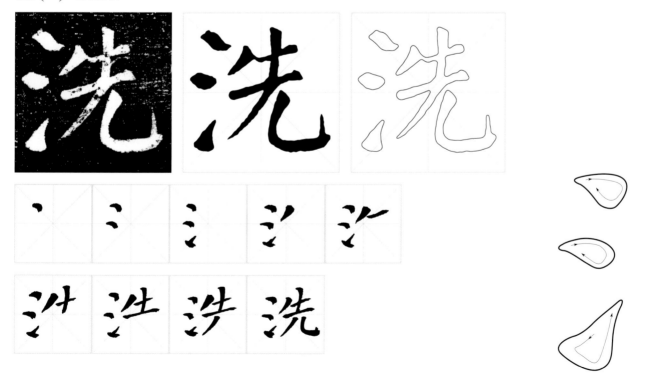

(9) Characters
with the Radical
日 (rìzìpáng)

映　时

映 (yìng) **reflect**

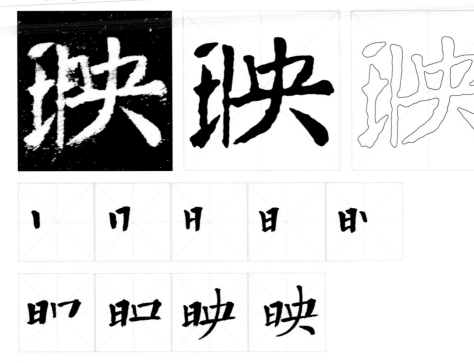

时 (shí) **time**

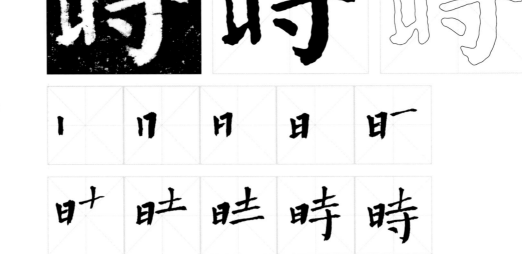

林 (lín) *forest*

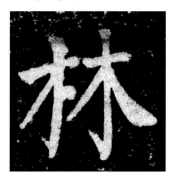 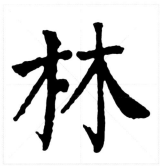

(10) Characters with the Radical 木 (mùzìpáng)

林　相

材 材 林

相 (xiāng) *together*

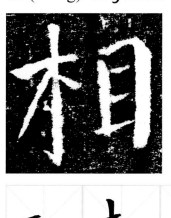 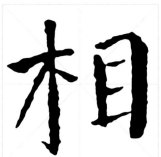

一 十 才 木 木

相 相 相 相

和 (hé) and

(11) Characters with the Radical 禾 (hémùpáng)

和　秋

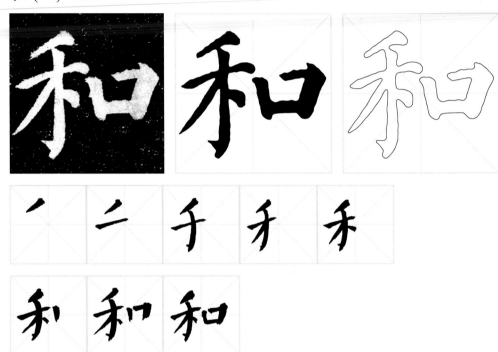

秋 (qiū) autumn

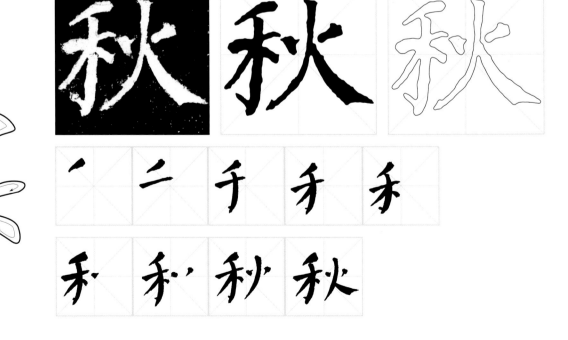

呼 (hū) *exhale*

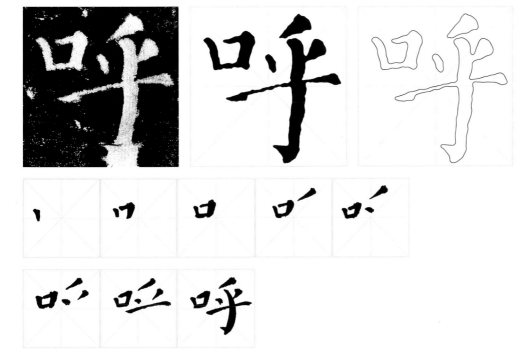

(12) Characters with the Radical 口 (kǒuzìpáng)

呼 唱

唱 (chàng) *sing*

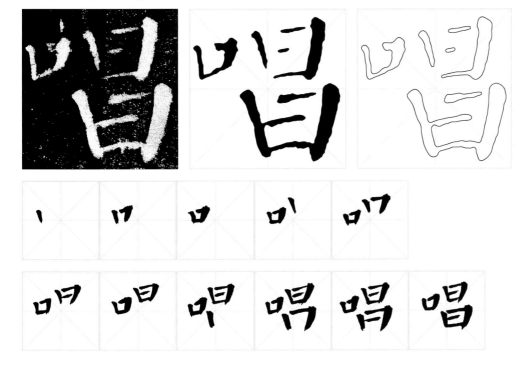

Groups of Characters

An integrated calligraphy work, no matter in the form of a vertical scroll, a horizontal scroll or a couplet, basically consists of three parts: the content, the signature and the seal. Usually, the content of writing would be a poem, a well-known sentence or even an article. In the signature, it is supposed to include the origin of the article, the time of writing and the writer's name as well. Of course the work should finally be stamped by a seal engraved with the writer's name.

(1) Vertical and Horizontal Scroll of Calligraphy, with " 人和 " as an Example

Horizontal Scroll

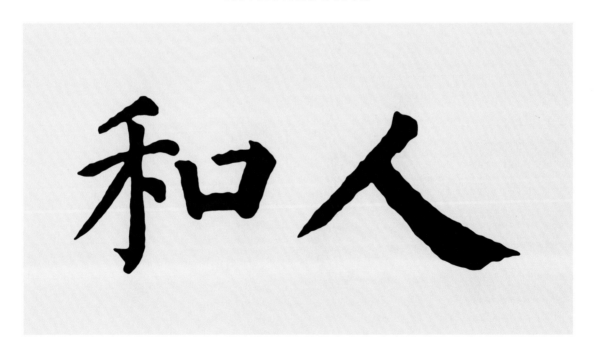

Vertical Scroll

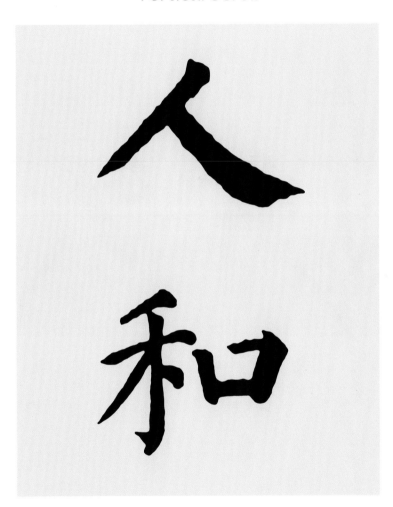

(2) Writing on a Fan, with " 一日千里 " as an Example

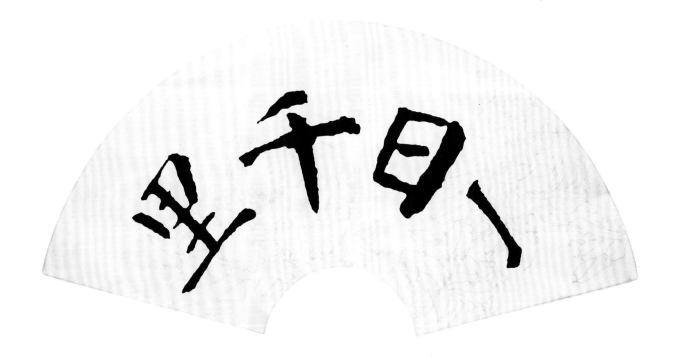

(3) Writing Antithetical Couplets, with " 天上一日，人间千年 " as an Example

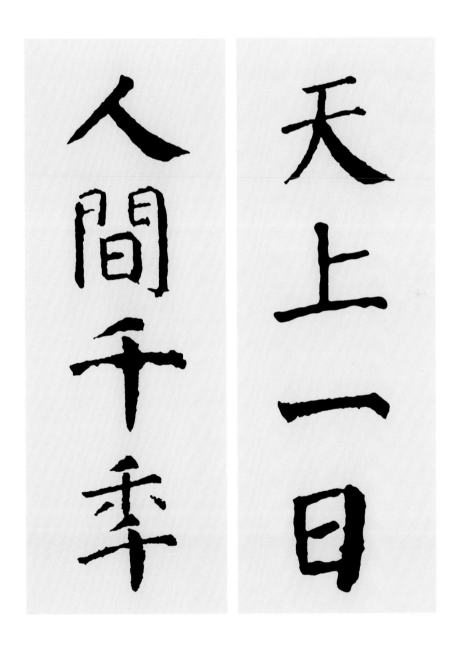

Gallery

Xuanshi Biao
(Zhong Yao, Wei Dynasty)

Xuanshi Biao is one of the small standard script pieces by Zhong Yao (151–230), the most important calligrapher in the Han-Wei period. The greatest contribution of Zhong Yao's works lies in the fact that they directly lead to the establishment of standard script as a standard style. This piece consists of standard, elegant characters with a somewhat flat structure, whose strokes are almost free from the influence of clerical script, its predecessor. This work is also considered the first of standard script piece in the history of Chinese calligraphy.

Huangting Jing
(Wang Xizhi, Jin Dynasty)

Huangting Jing is believed to be the masterpiece of the small standard script by Wang Xizhi. With altogether 100 lines, the original copy was written on a yellowish plain silk. It is considered the final turning point where Wang Xizhi completed his shift in standard script brushing. Although with varying sizes of Chinese characters, the piece as a whole looks rather natural and harmonious, making itself the prologue to the peak period of standard script writing in the Tang Dynasty.

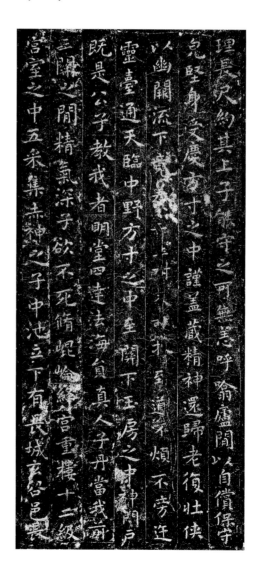

Luo Shen Fu
(Wang Xianzhi, Jin Dynasty)

Luo Shen Fu is a small standard script piece by Wang Xianzhi. It is said that Wang Xianzhi liked brushing the version of *Luo Shen Fu* so much that there have been more than one piece available. Compared with the small standard script of his father's, Wang Xizhi, Wang Xianzhi's is found to be freer and full of fun, displaying his spirits of innovation.

Cuan Longyan Stele
(Anonymous, Southern Dynasties, 420–589)

Cuan Longyan Stele was erected in 458, the writing on it serving as an example of the typical standard script style of the Southern and Northern period. The starting strokes of the characters show the trace of clerical script, but the majority is square in shape and, as such, the piece as a whole can be categorized as an early version of standard script writing. What is special of the work is that every character takes a different structure, while forming a well-organized whole in a unique, fancy and interesting manner.

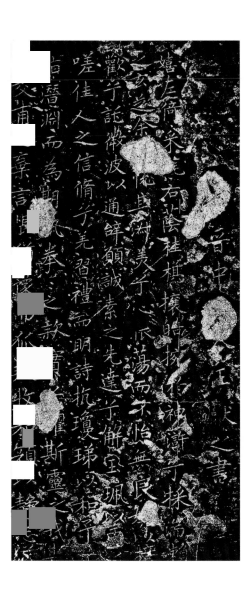

The Tablet of Longzang Temple
(Anonymous, Sui Dynasty)

The Tablet of Longzang Temple was finished in 586, and the carved writing on it is considered the most important of the surviving stone inscriptions for the Sui Dynasty. With exquisite brushing and square but dynamic shapes of characters, it presents itself as the established form of standard script, marking the immediate arrival of the peak period of standard script writing in the Tang Dynasty.

Inscription on the Sweet Wine Spring in the Jiucheng Palace
(Ouyang Xun, Tang Dynasty)

Inscription on the Sweet Wine Spring in the Jiucheng Palace is the best-known piece of writing by Ouyang Xun, who wrote it in 632 when he was at the advanced age of 75. The stele has been regarded as the calligraphic treasure of the Tang Dynasty, with its brushing style and character shapes strictly following the standard script rules of the Tang Dynasty—square and even strokes involving imposing power.

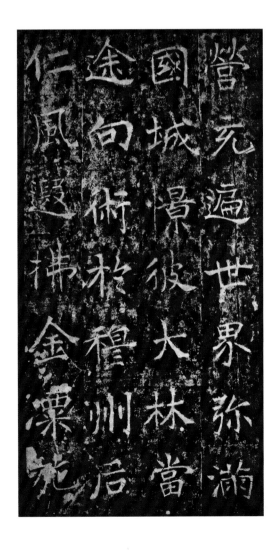

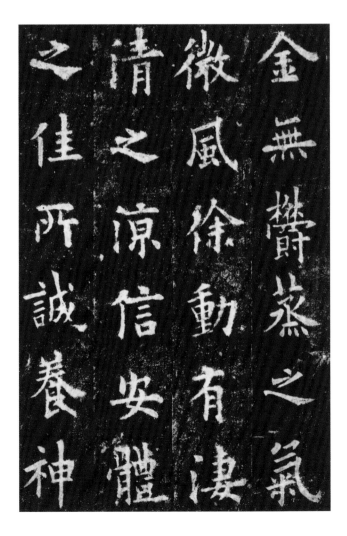

Wild Goose Pagoda Shengjiao Xu
(Chu Suiliang, Tang Dynasty)

Composed by Li Shimin, an emperor of the Tang Dynasty, and brushed by Chu Suiliang (596–658 or 659) on two steles, *Wild Goose Pagoda Shengjiao Xu* well reflects the characteristics of Chu's writing style. The strokes of the characters look rather thin and slender at the first glance, but a closer examination reveals much power and elasticity permeated into them. The skills of clerical script and running script are observed in some characters, which add much to the liveliness and dynamics of the work.

Xuanmita Stele
(Liu Gongquan, Tang Dynasty)

Xuanmita Stele, the stele inscription with altogether 1,512 Chinese characters, was erected in 841 when Liu Gongquan (778–865) was 64 years old. The work features clear startings and endings of brushing, slenderer horizontal strokes, a general symmetry between the right and the left of a single character but with a slightly higher right part, a compact structure, and an overall impression of freedom from sloppiness.

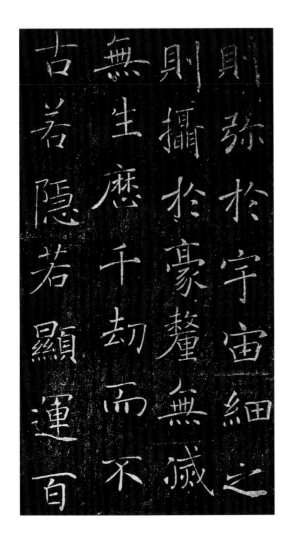

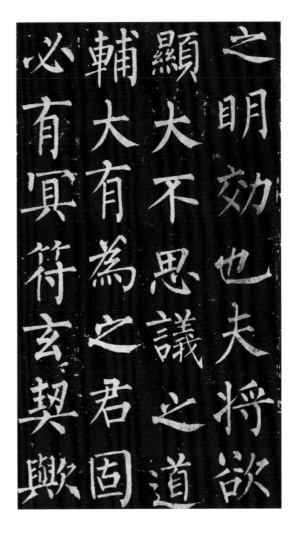

Appendices

Index of Calligraphers & Works

1. Anonymous 佚名
 Cuan Longyan Stele 《爨龙颜碑》73

2. Anonymous 佚名
 The Tablet of Longzang Temple 《龙藏寺碑》11, 74

3. Anonymous 佚名
 Tombstone-Record of Beauty Tong 《美人董氏墓志铭》11

4. Chu Suiliang 褚遂良 (596–658 or 659) 75
 Wild Goose Pagoda Shengjiao Xu 《雁塔圣教序》75

5. Dong Qichang 董其昌 (1555–1636) 16
 An Autumn Landscape 《秋兴八景图》16

6. Fu Shan 傅山 (1607–1684) 16

7. He Shaoji 何绍基 (1799–1873) 17

8. Huai Su 怀素 (725–785) 12, 13
 Autobiography 《自叙帖》13

9. Huang Tingjian 黄庭坚 (1045–1105) 15

10. Kang Youwei 康有为 (1858–1927) 17

11. Li Si 李斯 (284–208 BC) 9

12. Liu Gongquan 柳公权 (778–865) 75
 Xuanmita Stele 《玄秘塔碑》75

13. Lu You 陆游 (1125–1210) 15

14. Mi Fu 米芾 (1051–1107) 15
 Xin'en Tie 《新恩帖》15

15. Ouyang Xun 欧阳询 (557–641) 12, 18, 74
 Inscription on the Sweet Wine Spring in the Jiucheng Palace 《九成宫醴泉铭》12, 74

16. Shen Zengzhi 沈曾植 (1850–1922) 17

17. Su Shi 苏轼 (1037–1101) 15
 Xinsui Zhanqing Tie 《新岁展庆帖》15

18. Wang Xianzhi 王献之 (344–388) 10, 11, 12, 16, 73
 Yatouwan Tie 《鸭头丸帖》11
 Mid-Autumn Letter 《中秋帖》11
 Luo Shen Fu 《洛神赋》73

19. Wang Xizhi 王羲之 (303–361) 7, 8, 10, 11, 12, 16, 72, 73
 Preface to the Orchid Pavilion Collection 《兰亭序》7, 8, 11
 Letter to My Aunt 《姨母帖》11
 Timely Clearing after Snowfall 《快雪时晴》11
 Huangting Jing 《黄庭经》72

20. Wu Changshuo 吴昌硕 (1844–1927) 17

21. Yan Zhenqing 颜真卿 (709–785) 7, 8, 12, 18, 19
 Draft of the Eulogy for My Nephew 《祭侄文稿》8, 19
 Qinli Stele 《勤礼碑》18, 19
 Duobao Pagoda Stele 《多宝塔碑》18
 Ode to Dongfang Shuo 《东方朔画赞》18
 Letter on the Controversy over Seating Protocol 《争座位帖》19

22. Yang Ningshi 杨凝式 (875–954) 15
 《韭花帖》*Jiuhua Tie* 15

23. Yu Shinan 虞世南 (558–638) 12, 25
 Stele in Temple of Confucius 《孔子庙堂碑》12

24. Zhang Xu 张旭 (675–750) 12, 13, 18

25. Zhao Mengfu 赵孟頫 (1254–1322) 15, 16

26. Zhao Zhiqian 赵之谦 (1829–1884) 17

27. Zhong Yao 钟繇 (151–230) 72
 Xuanshi Biao 《宣示表》72

28. Zhu Da 朱耷 (1626–1705) 16

29. Zhu Xi 朱熹 (1130–1200) 15

Chronology of Chinese History

Xia Dynasty	2070–1600 BC
Shang Dynasty	1600–1046 BC
Zhou Dynasty	1046–256 BC
Western Zhou Dynasty	1046–771 BC
Eastern Zhou Dynasty	770–256 BC
Spring and Autumn Period	770–476 BC
Warring States Period	475–221 BC
Qin Dynasty	221–206 BC
Han Dynasty	206 BC–AD 220
Western Han Dynasty	206 BC–AD 25
Eastern Han Dynasty	25–220
Three Kingdoms	220–280
Wei	220–265
Shu Han	221–263
Wu	222–280
Jin Dynasty	265–420
Western Jin Dynasty	265–316
Eastern Jin Dynasty	317–420
Northern and Southern Dynasties	420–589
Southern Dynasties (Song, Qi, Liang, Chen)	420–589
Northern Dynasties	439–581
Sui Dynasty	581–618
Tang Dynasty	618–907
Five Dynasties and Ten Kingdoms	907–960
Song Dynasty	960–1279
Northern Song Dynasty	960–1127
Southern Song Dynasty	1127–1279
Yuan Dynasty	1279–1368
Ming Dynasty	1368–1644
Qing Dynasty	1644–1911

Bibliography

1. 中国书法博物馆

 Zhong Guo Shu Fa Bo Wu Guan Museum of Chinese Calligraphy

 (Han Yan Publishing House 2003)

2. 书法技要—楷书（勤礼碑）

 Shu Fa Ji Yao—Kai Shu (Qin Li Bei) The Art of Calligraphy—*Kaishu* (*Qin Li Bei*)

 (Jiang Su Art Publishing House 2005)

3. 颜勤礼碑及其笔法

 Yan Qin Li Bei Ji Qi Bi Fa Yan Qinli Stele and Writing ways by Wang Xiaoyong

 (Xi-Ling Seal House 2006)

4. 颜真卿勤礼碑（楷书）

 Yan Zhen Qing Qin Li Bei (Kai Shu) Yan Zhenqing *Qinli* Stele (*Kaishu*) by Xiang Weiwei

 (Capital Normal University Publishing House 1996)

5. 心印

 Xin Yin Images of the Mind by Wen C. Fong

 (Princeton University Press 1984)

6. The Embodied Image by Robert E. Harrist, JR. & We C. Fong

 (Princeton University Press 1999)

Glossary

1. Oracle bone script *Jiaguwen* 甲骨文
2. Bronze script *Jinwen* 金文
3. Stone inscriptions *Shiguwen* 石鼓文
4. Written by ink and brush on textile materials *Boshu* 帛书
5. Writing on wood or bamboo with brush *Jiandu* 简牍
6. Small-seal script *Xiaozhuan* 小篆
7. Clerical script *Lishu* 隶书
8. Cursive script *Caoshu* 草书
9. Standard script *Kaishu* 楷书
10. Running script *Xingshu* 行书
11. True script or standard script *Zhenshu or Zhengshu* 真书、正书
12. Yan style *Yanti* 颜体
13. Four Treasures of Calligraphy Study *Wen Fang Si Bao* 文房四宝
14. Thumb-fingers method *Wu Zhi Zhi Bi Fa* 五指执笔法
15. The Eight Principles of the Character Yong *Yong Zi Ba Fa* "永"字八法

16. Beginning the strokes *Qi Bi Fa* 起笔法
17. Continuing the strokes *Xing Bi Fa* 行笔法
18. Finishing the strokes *Shou Bi Fa* 收笔法
19. Horizontal stroke *Heng* 横
20. Vertical stroke *Shu* 竖
21. Down stroke to the left *Pie* 撇
22. Down stroke to the right *Na* 捺
23. Dot *Dian* 点
24. Turning stoke *Zhe* 折
25. Hooked stroke *Gou* 钩
26. Rising stroke *Ti* 提
27. Complex stokes *Fu He Bi Hua* 复合笔画
28. Radical *Bu Shou* 部首
29. Horizontal scroll *Heng Fu* 横幅
30. Vertical scroll *Tiao Fu* 条幅
31. Fan *Shan Mian* 扇面
32. Antithetical couplets *Dui Lian* 对联